UNICORNS ARE JERKS

coloring & activity book

drawn and written by
Theo Nicole Lorenz

 sourceboc

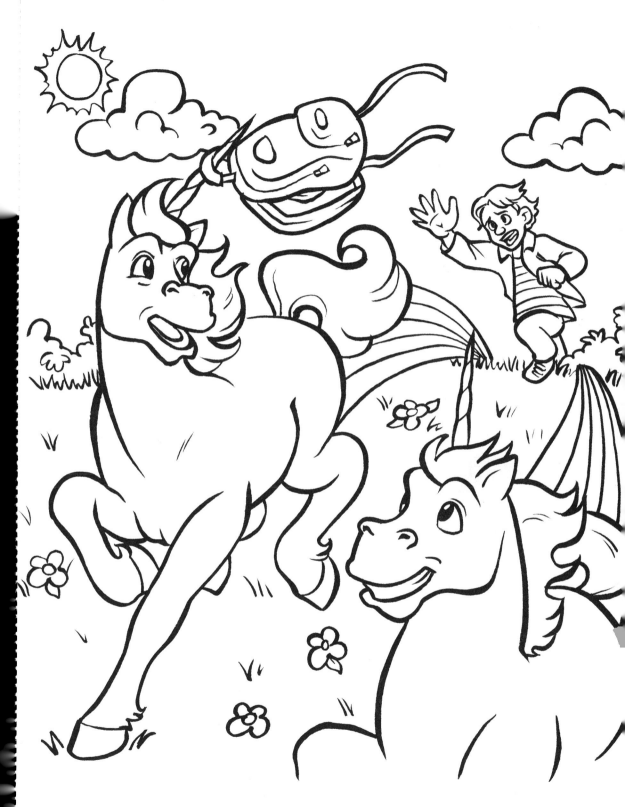

Everyone thinks unicorns are pure and magical,
but really they're jerks.

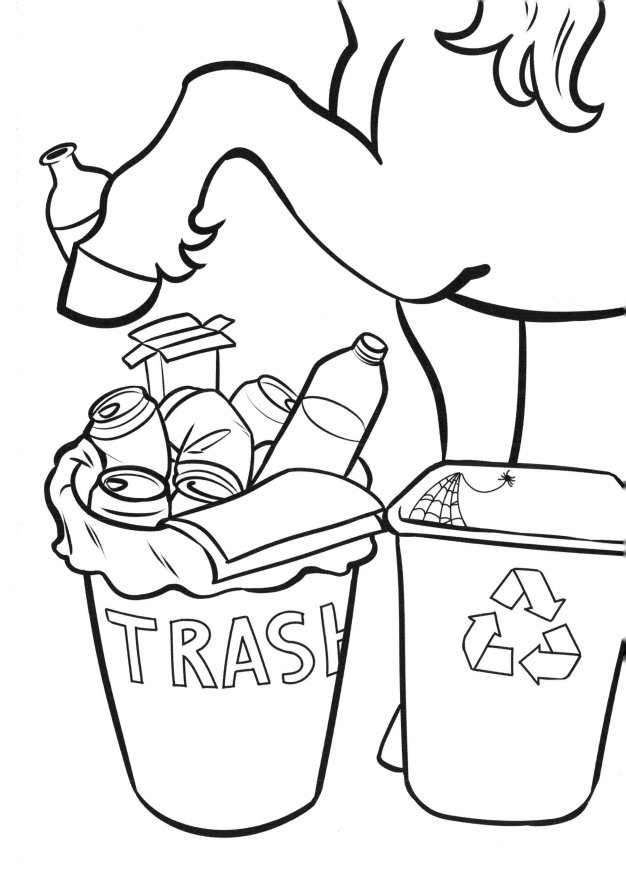

Unicorns don't recycle.

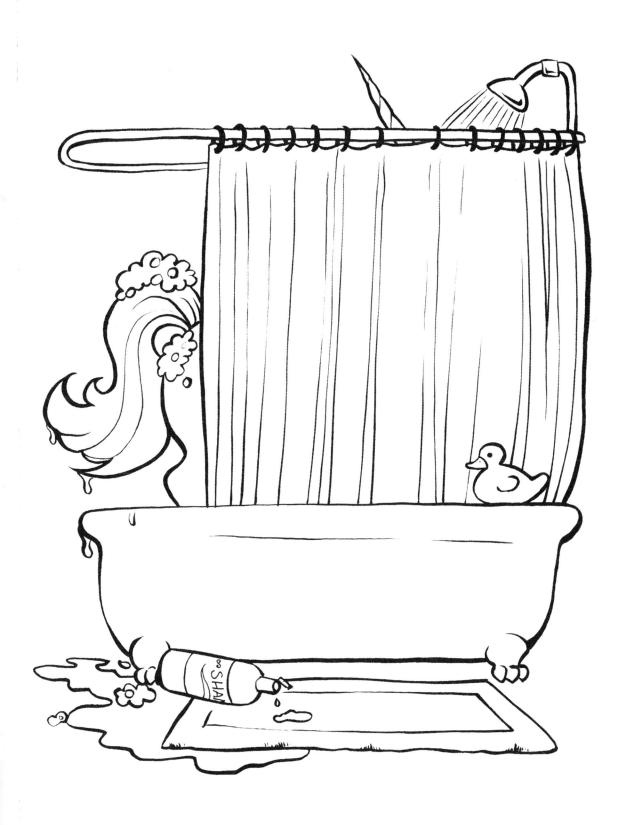

Unicorns use up all of your shampoo.

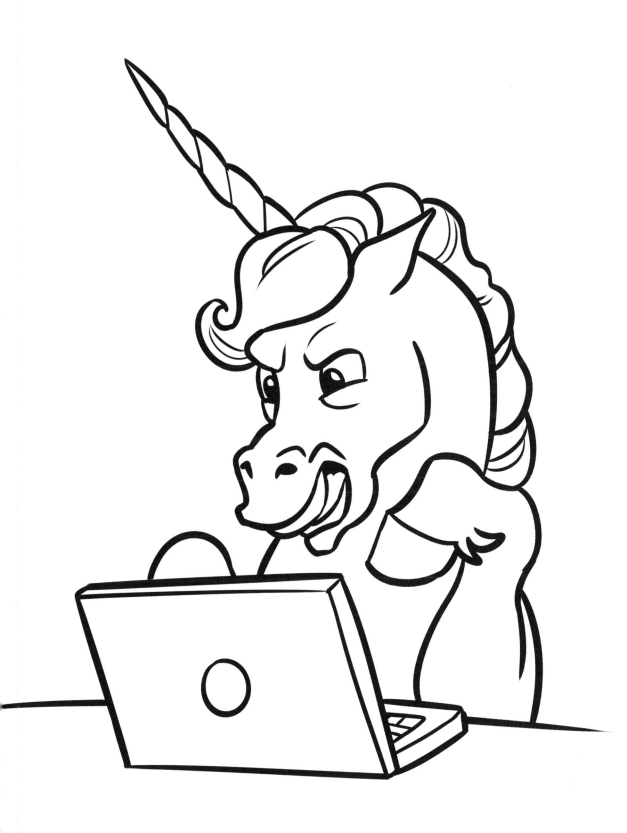

Unicorns start fights in Internet comment sections.

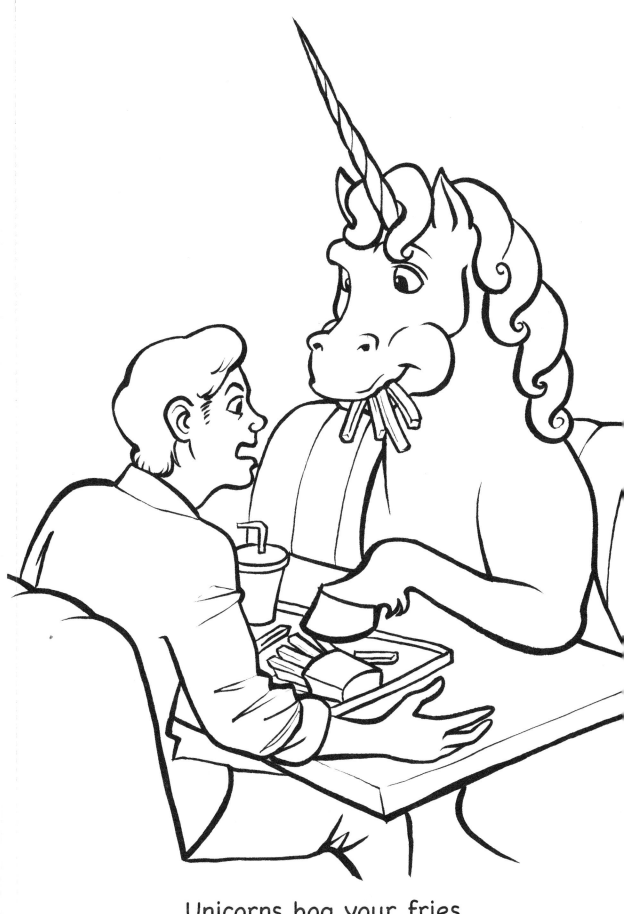

Unicorns hog your fries.

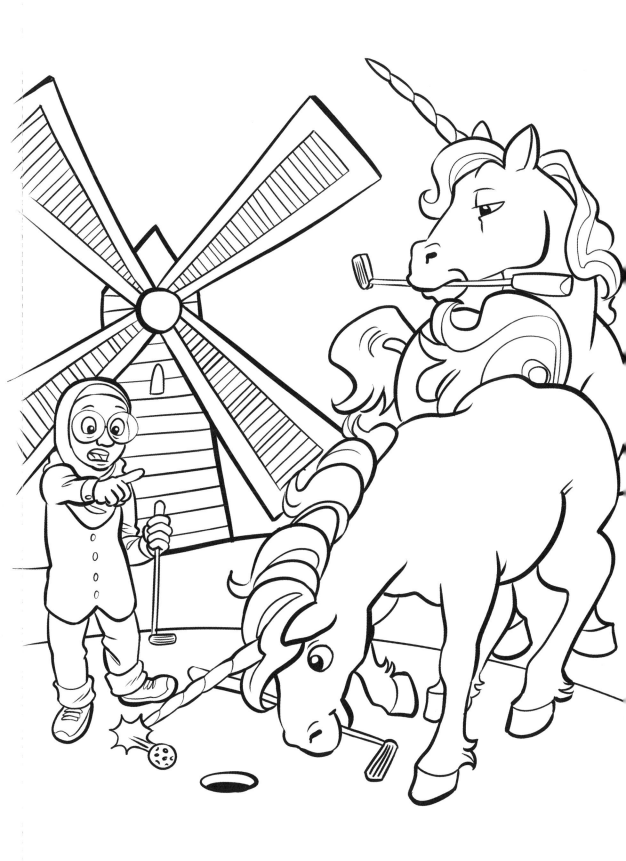

Unicorns cheat at minigolf.

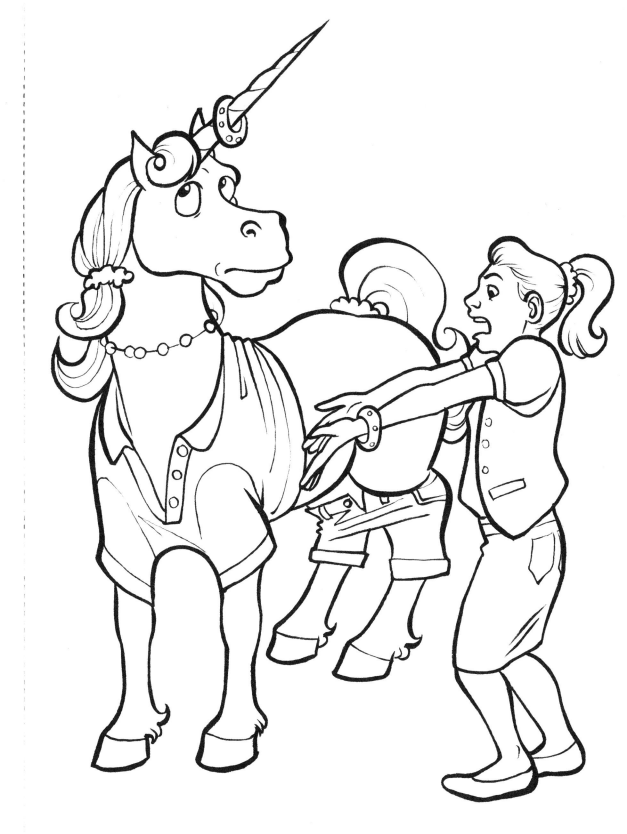

Unicorns borrow your clothes
without asking permission
and stretch them out.

Complete the crossword puzzle for a list of things unicorns have borrowed from you.

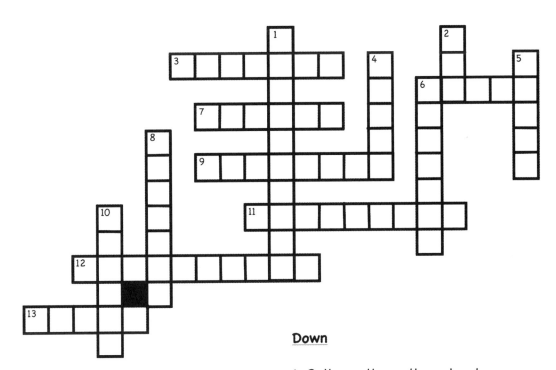

Down

1. Ball you throw through a hoop
2. Vehicle you paid good money for
4. Unicorns borrowed your favorite _____ and haven't even watched it
5. You can't even text them to complain because they have your _____ too
6. Appliance for making smoothies
8. Small, furry pet that plays in a wheel
10. Digging implement

Across

3. A unicorn borrowed five _____ and he's not paying it back
6. You can't do your hair because a unicorn has your ____
7. Outerwear with sleeves that doesn't fit unicorns
9. An adhesive more magical than unicorn spit
11. Your unicorn neighbors borrowed your _____ but never mowed their lawn
12. Electric tool for making holes
13. Give me back my _____, unicorn! You have hooves, they don't even fit!

Across: 3. dollars 6. brush 7. jacket 9. duct tape 11. lawn mower 12. power drill 13. shoes
Down: 1. basketball 2. car 4. movie 5. phone 6. blender 8. hamster 10. shovel

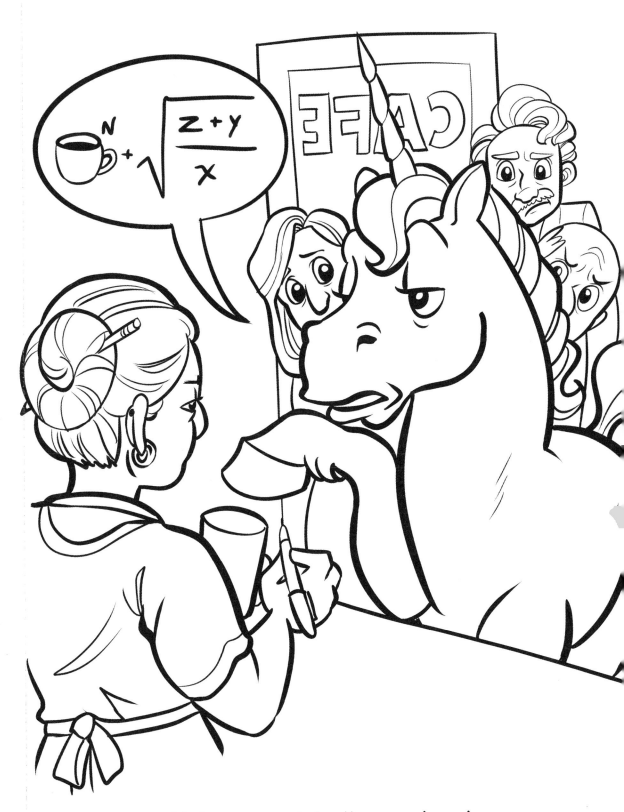

Unicorns cut in line and order
the most complicated coffee ever.

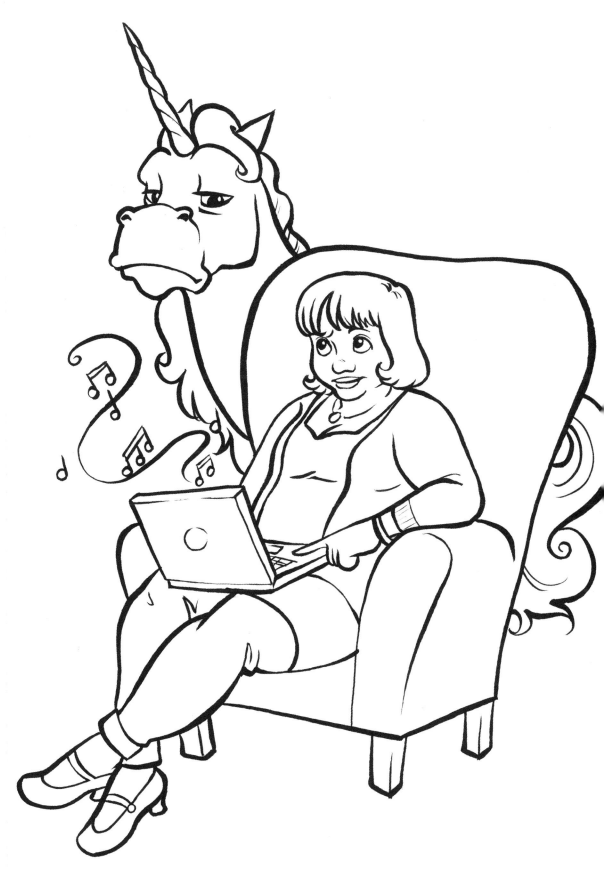

Unicorns judge your taste in music.

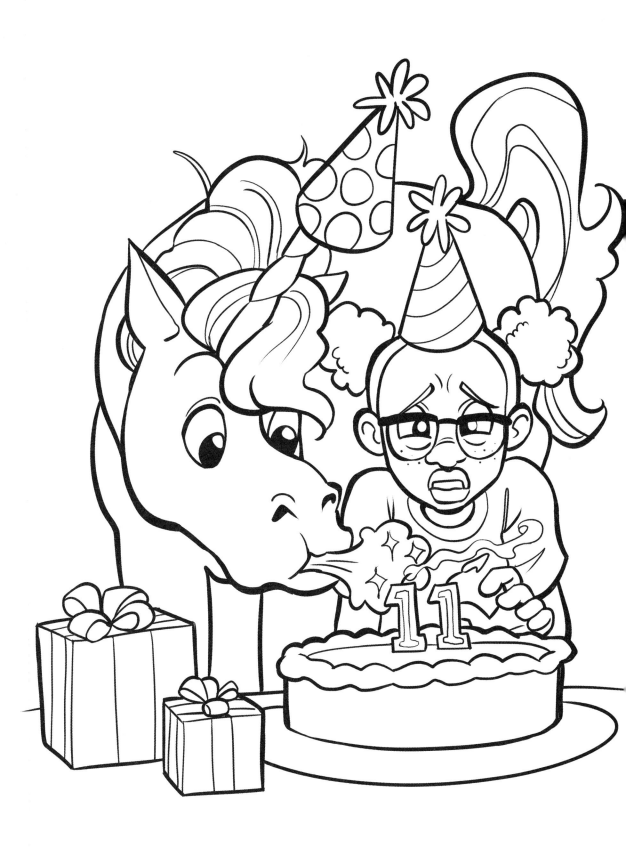

Unicorns blow out YOUR birthday candles.

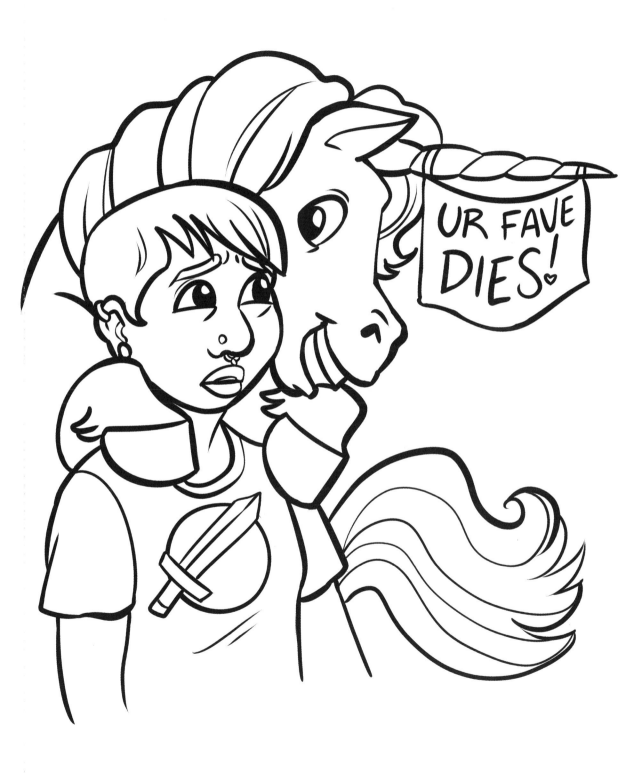

Unicorns spoil your favorite show.

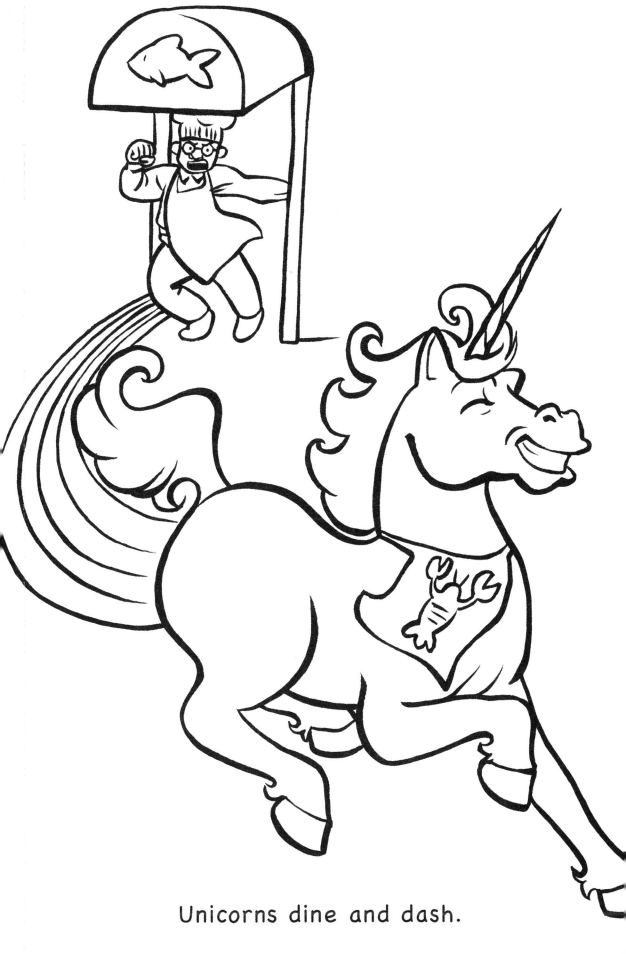

Unicorns dine and dash.

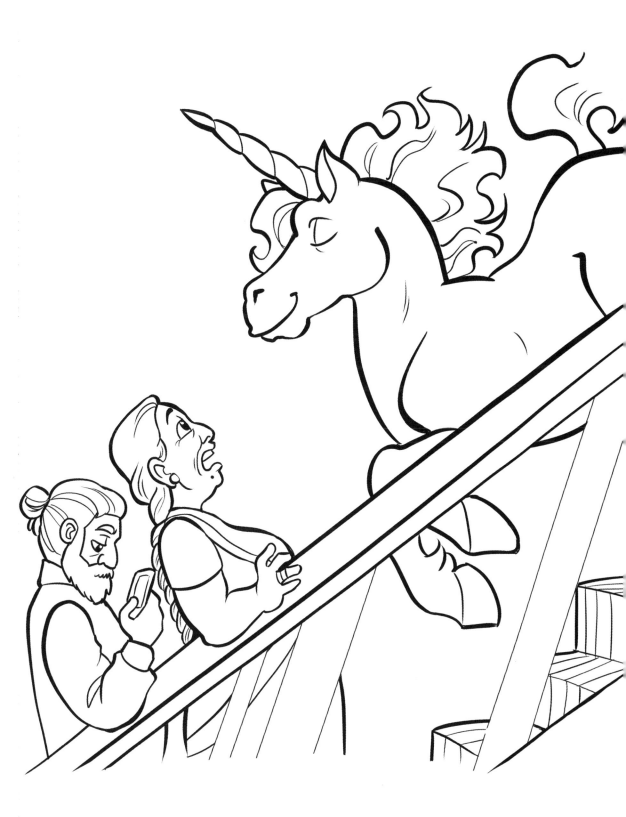

Unicorns go down the up escalator.

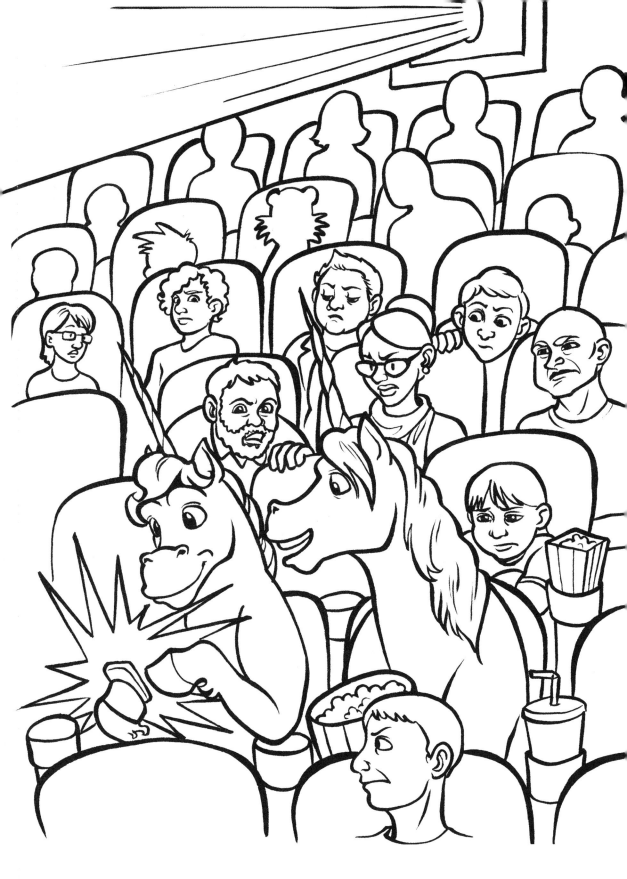

Unicorns talk and text in movie theaters.

Color the areas with the dots
to reveal an important message.

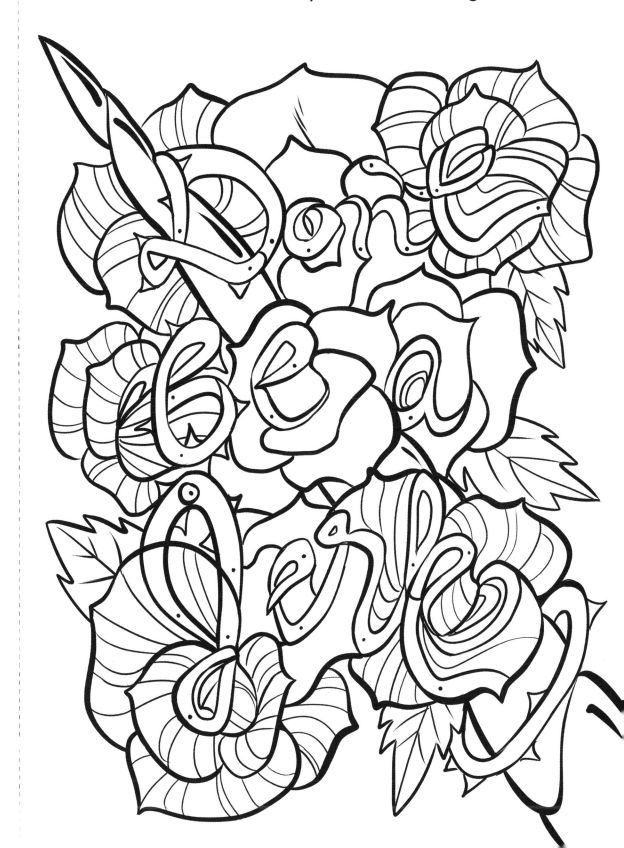

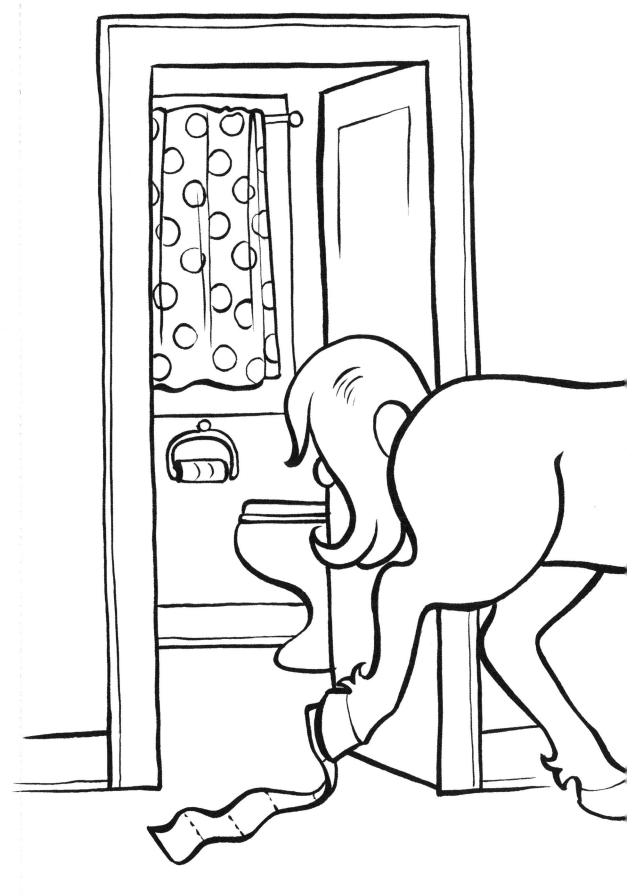

Unicorns don't replace the toilet paper roll.

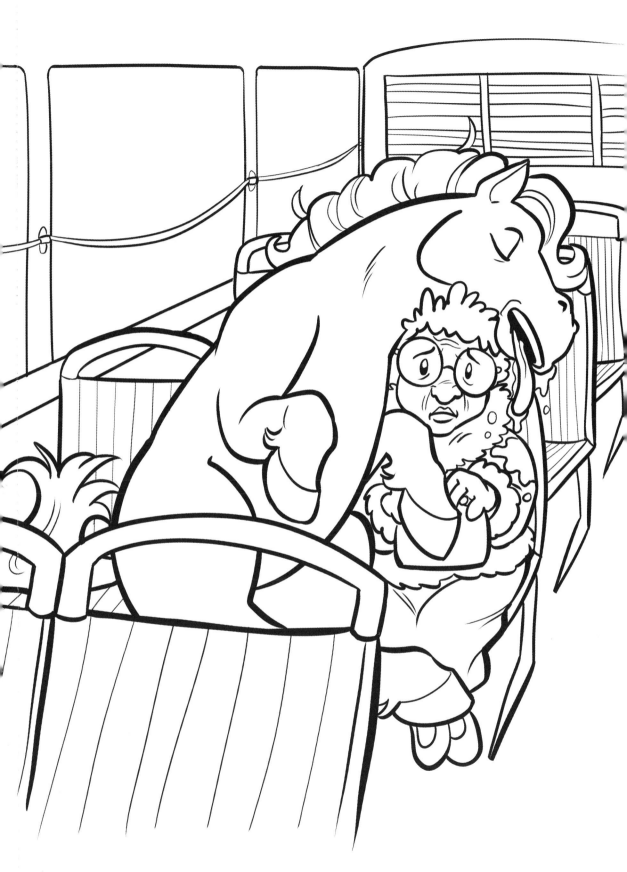

Unicorns don't respect personal space.

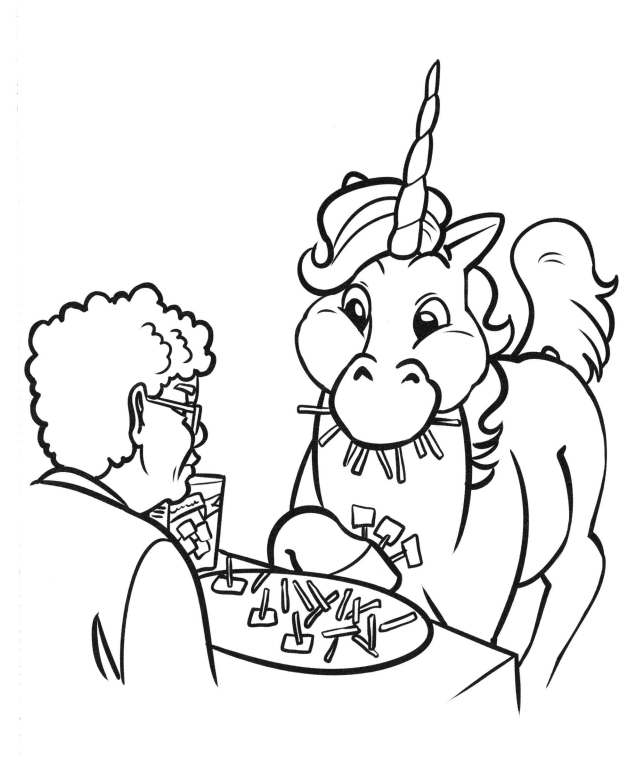

Unicorns take too many free samples
at the grocery store.

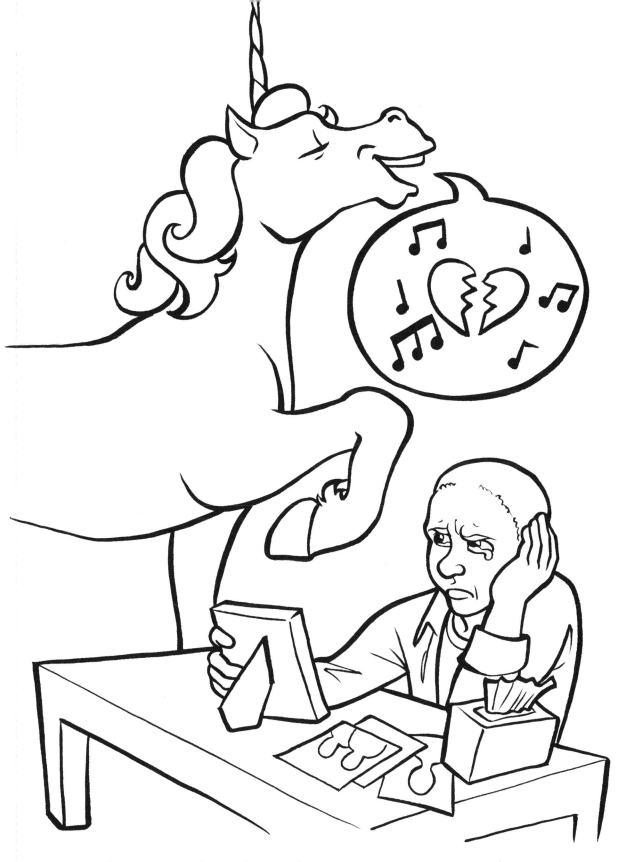

Unicorns sing breakup songs around you
when you've just been dumped.

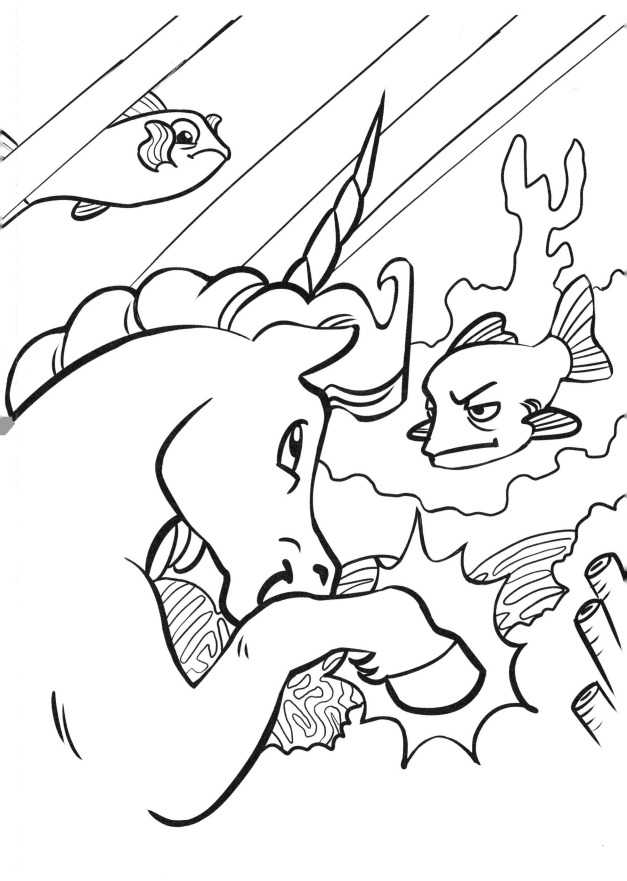

Unicorns tap on the glass at the aquarium.

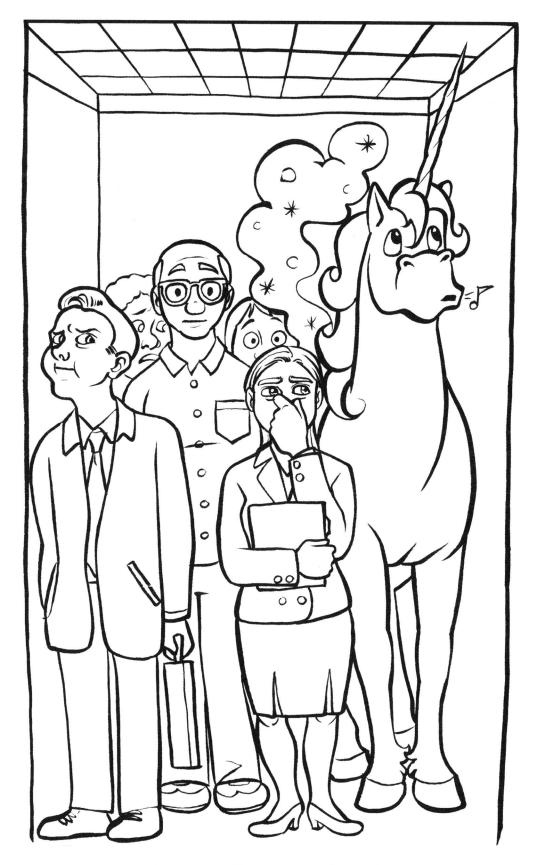

Unicorns fart in elevators.
On purpose.

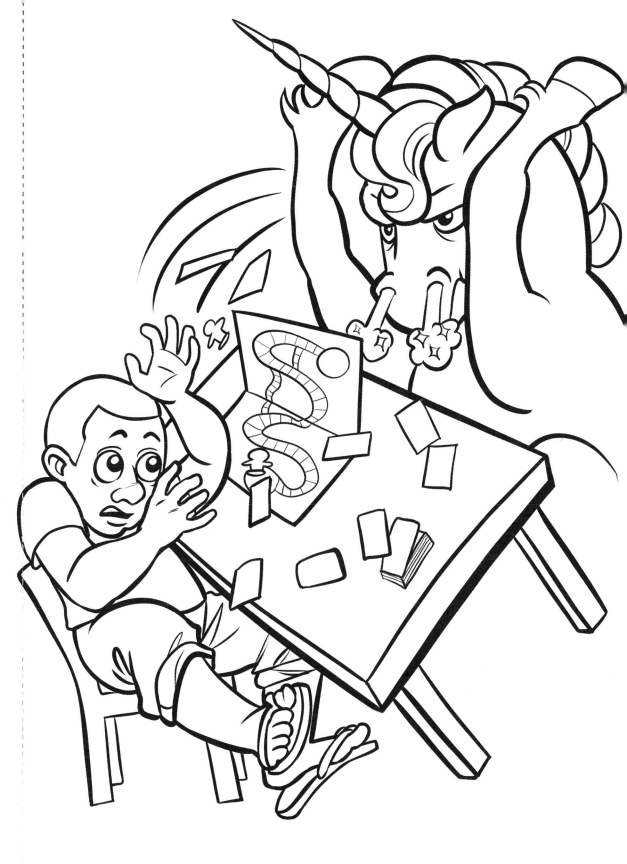

Unicorns get way too competitive
about board games.

Finish the drawing to show what the unicorn drew on your walls!

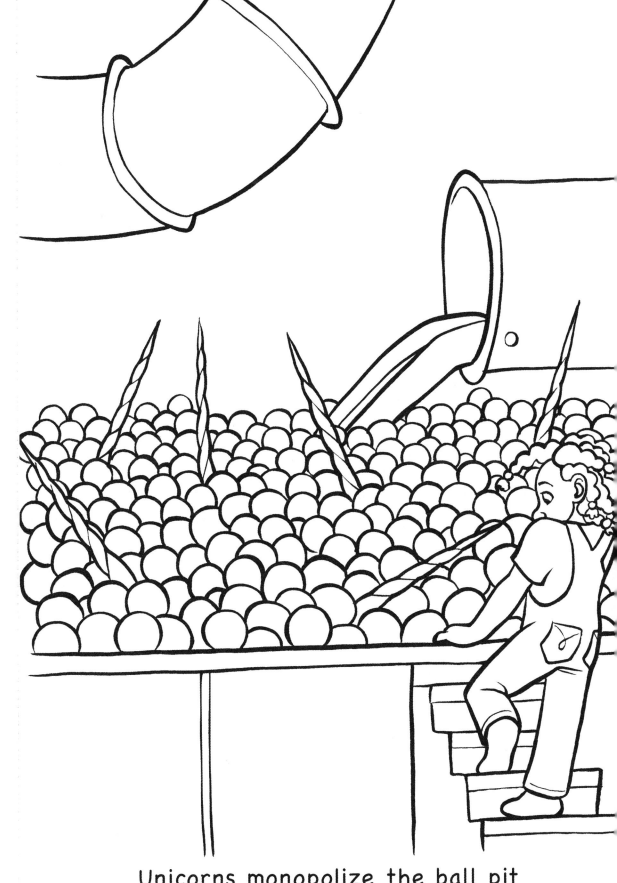

Unicorns monopolize the ball pit
and don't let anyone else in.

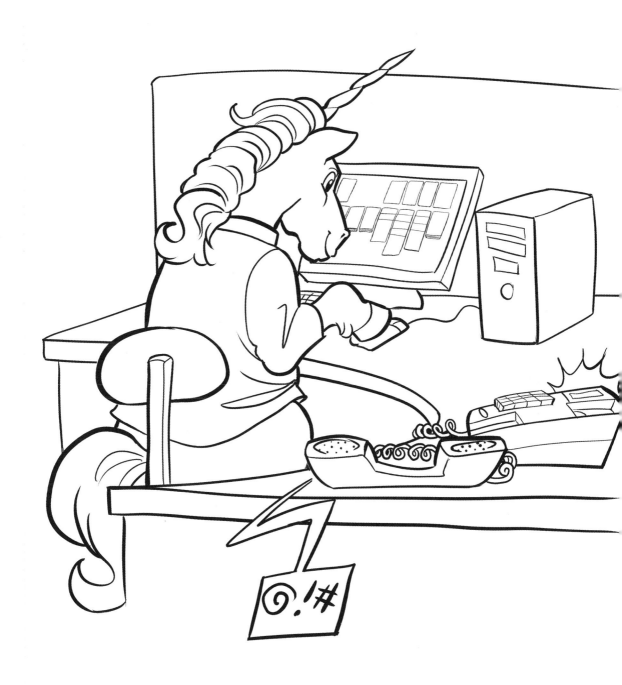

Unicorns put you on hold
so they can play solitaire.

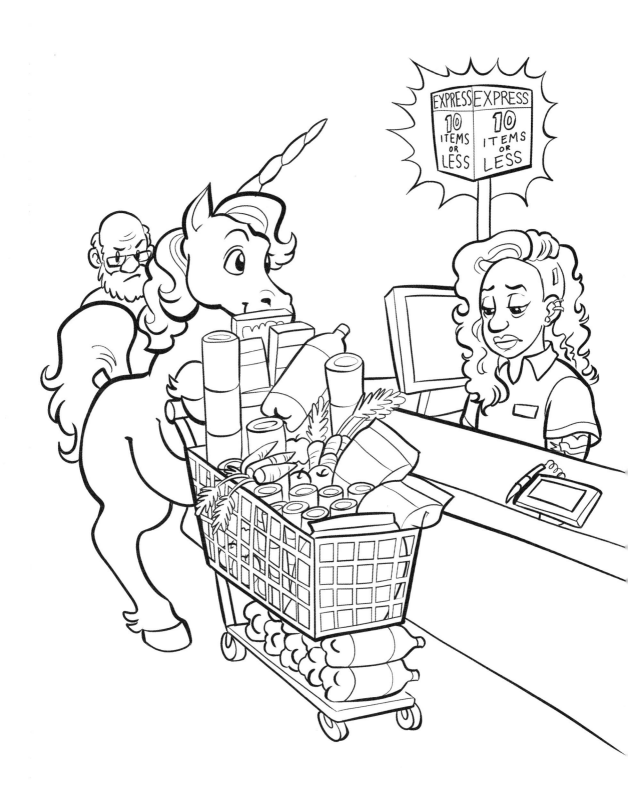

Unicorns go through the express lane
with a full cart.

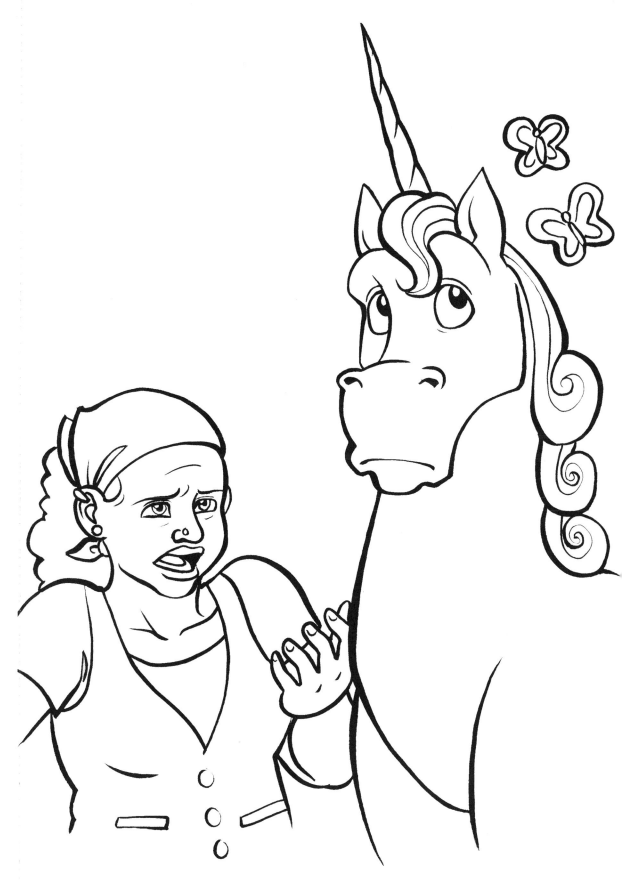

Unicorns never listen.

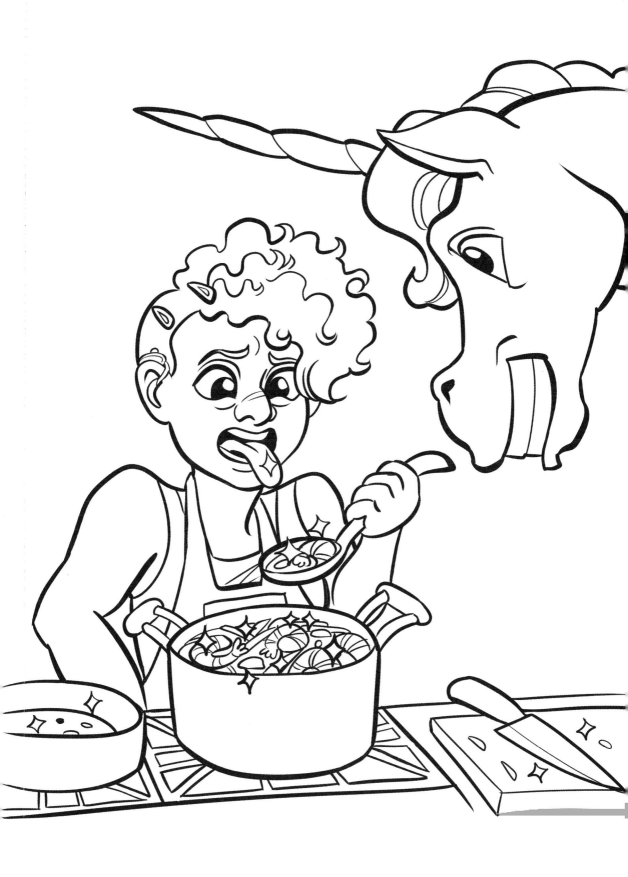

Unicorns get glitter EVERYWHERE.

Use this form to notify a unicorn
that they have wronged you!

OFFICIAL NOTICE
Unicorn Complaint

To: _____ From: _____
name of unicorn name of sender

This notice serves to alert you that you were a jerk to me.
Date of jerky behavior: _____
Detailed description of your jerky behavior: _____

How that made me feel: | **How you can make amends:**

- [] hurt
- [] betrayed
- [] uncomfortable
- [] other: _____
- [] offended
- [] angry
- [] grossed out

- [] apologize
- [] return my stuff
- [] pay me back
- [] other: _____
- [] change your behavior
- [] clean up your mess
- [] magical favor(s)

Consequences if you choose not to make amends: _____

I value you as a...

- [] friend
- [] romantic partner
- [] colleague
- [] mythological concept
- [] roommate
- [] fellow bus passenger

and hope that we can resolve this soon.

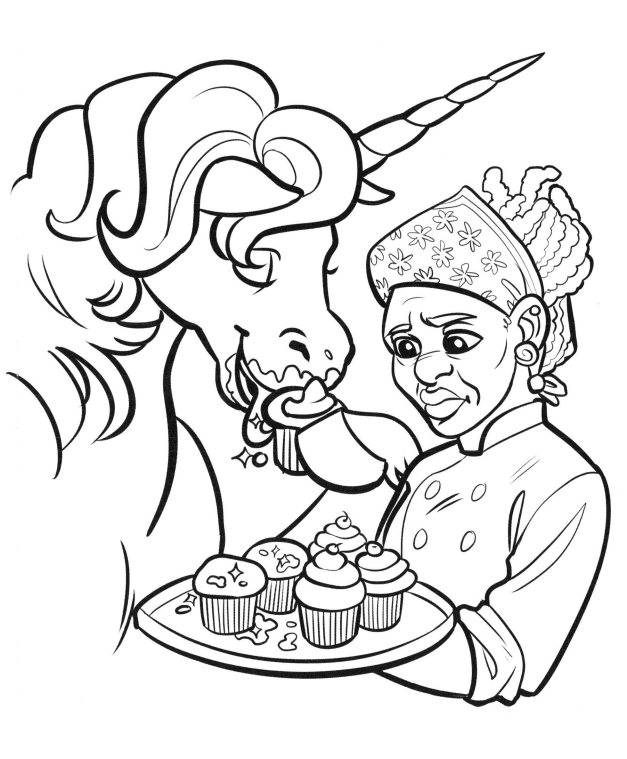

Unicorns lick the frosting off cupcakes
and put them back.

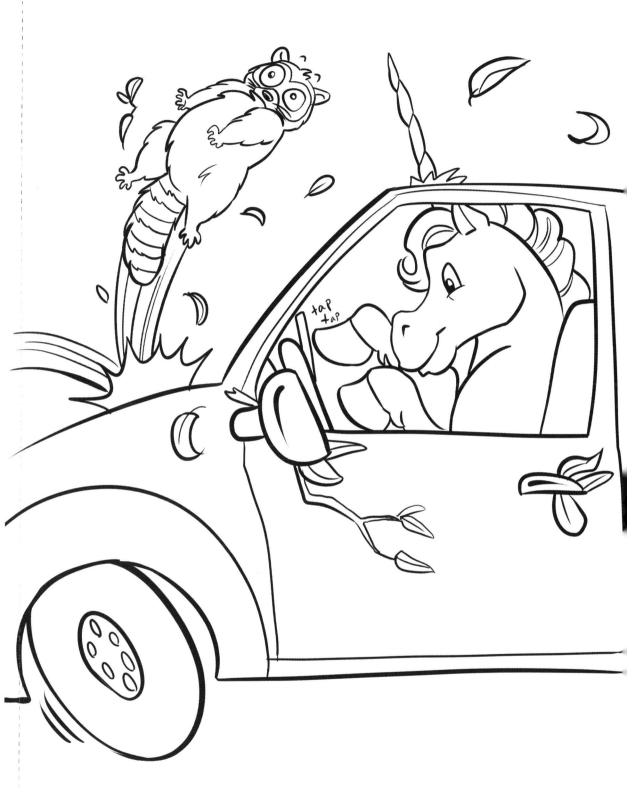

Unicorns text while driving.

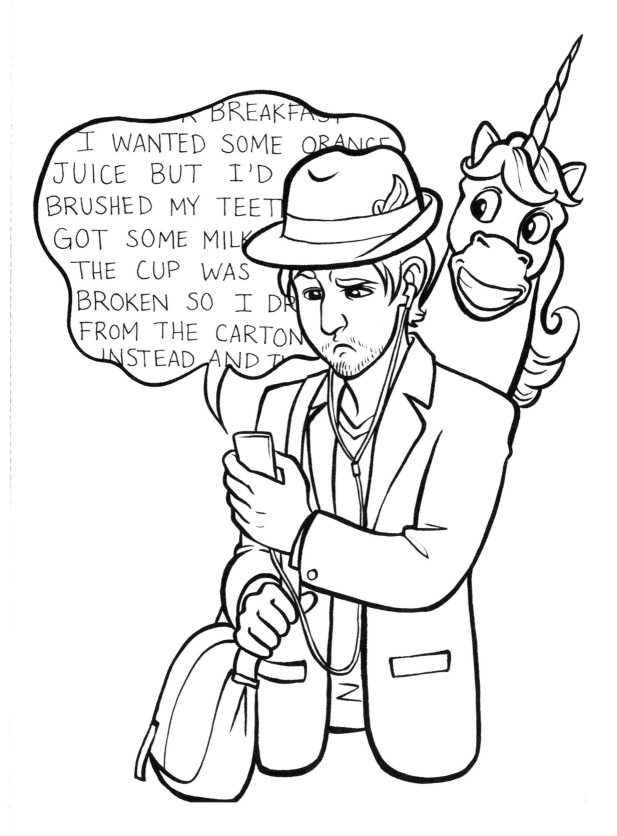

Unicorns delete your music collection
and replace it with their own audio memoirs.

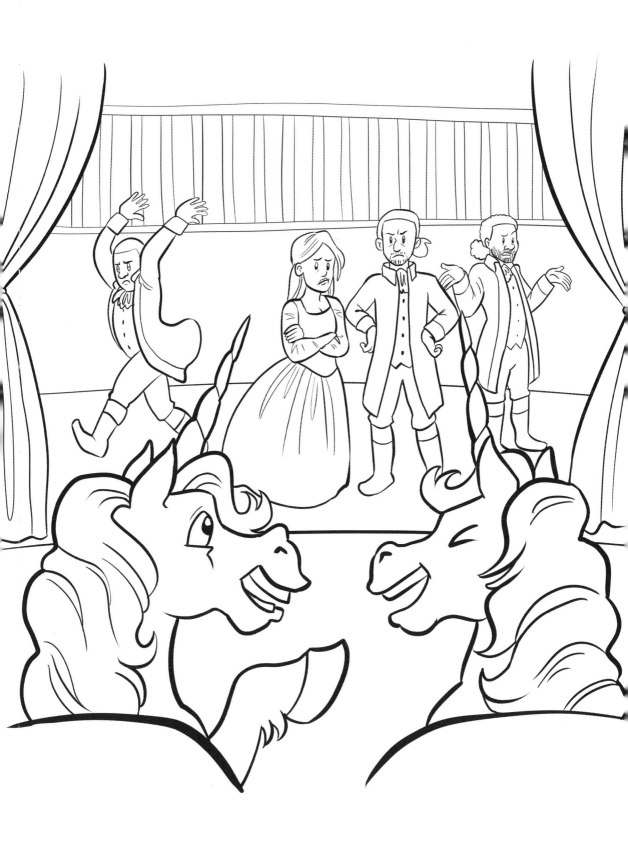

Unicorns heckle the actors.

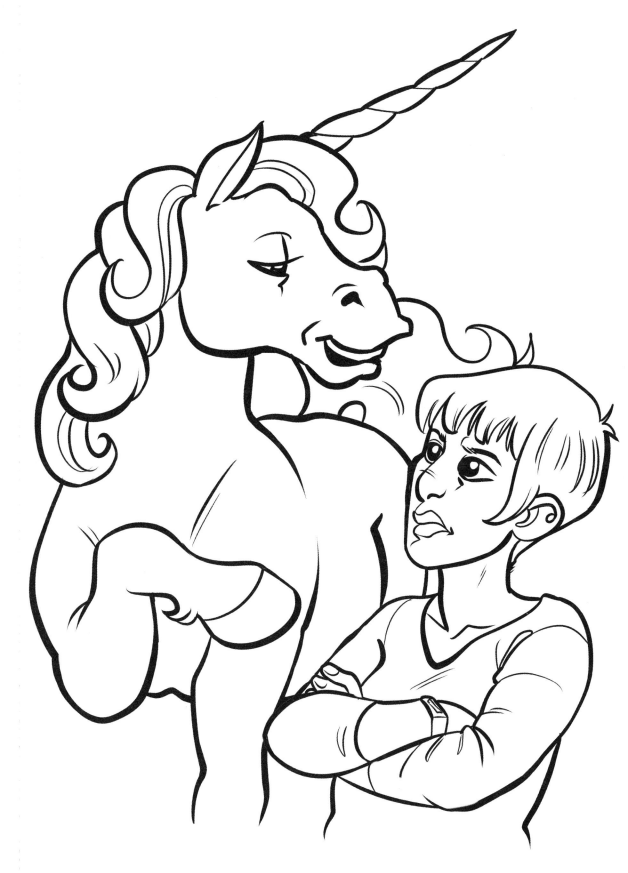

Unicorns tell mean jokes then say
it's YOUR fault if you get offended.

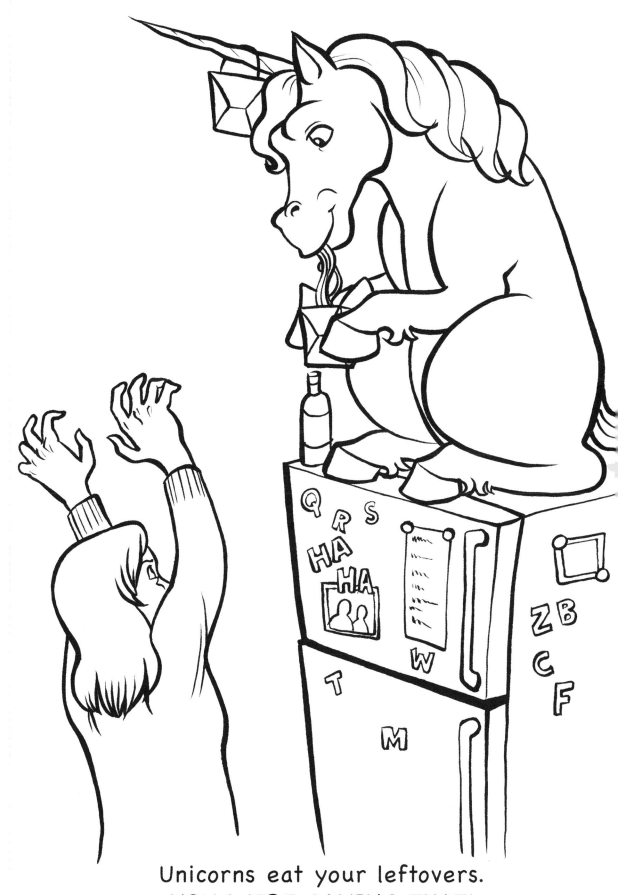

Unicorns eat your leftovers.
YOU WERE SAVING THAT!

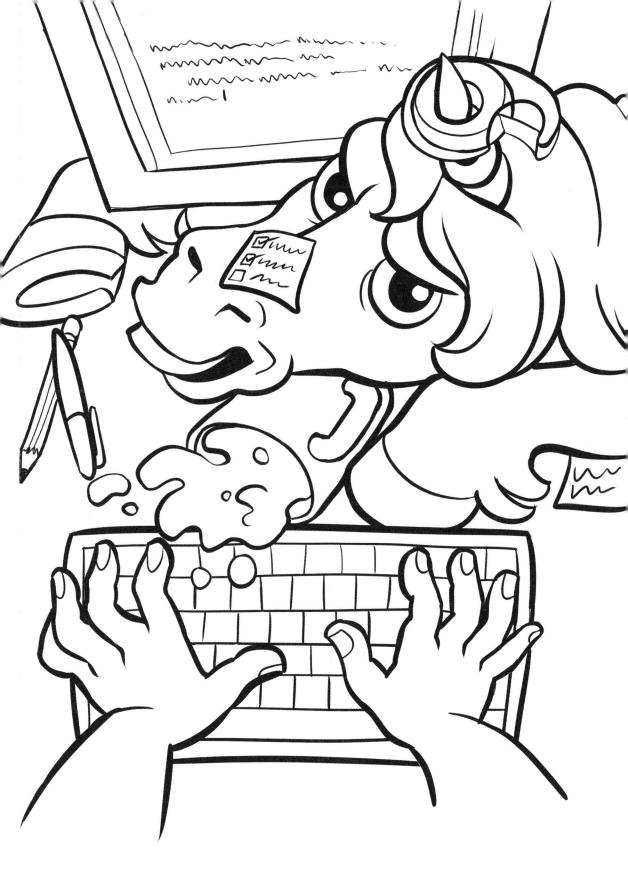

Unicorns will do anything to get your attention.

Navigate the maze to survive a road trip with a unicorn!

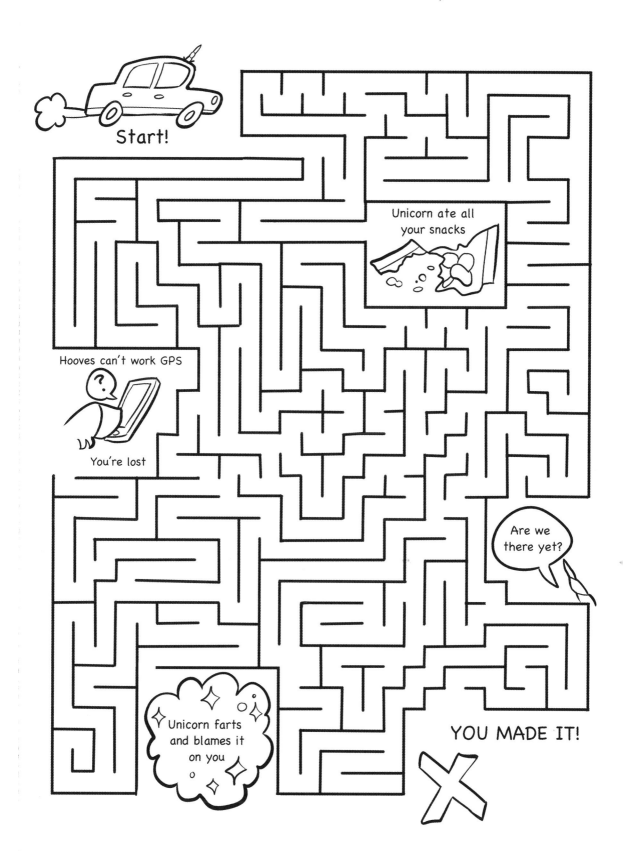

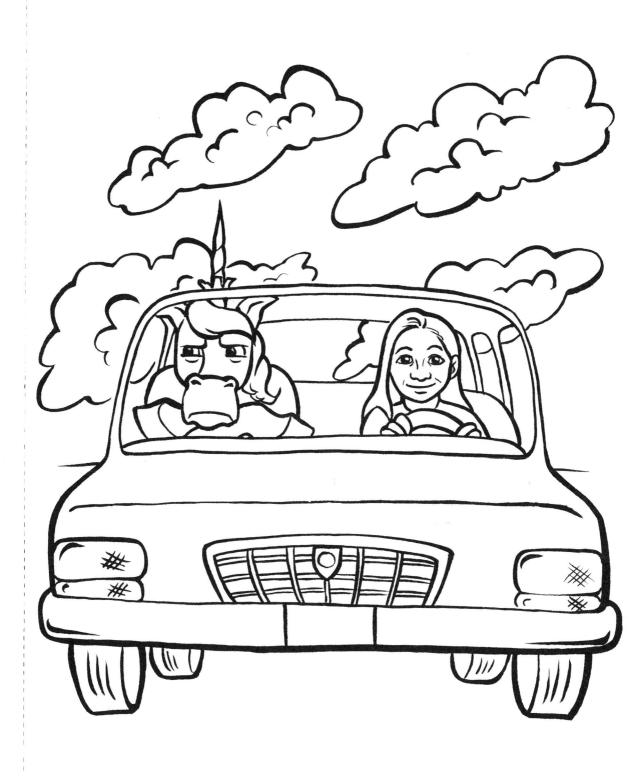

Unicorns spend the whole trip sulking
because you wouldn't let them drive.

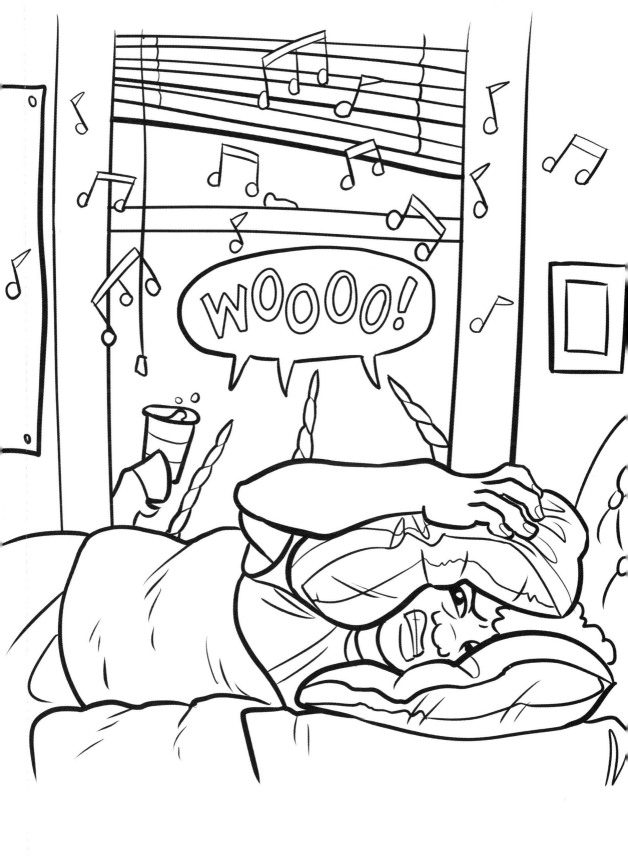

Unicorns throw loud parties
while you're trying to sleep.

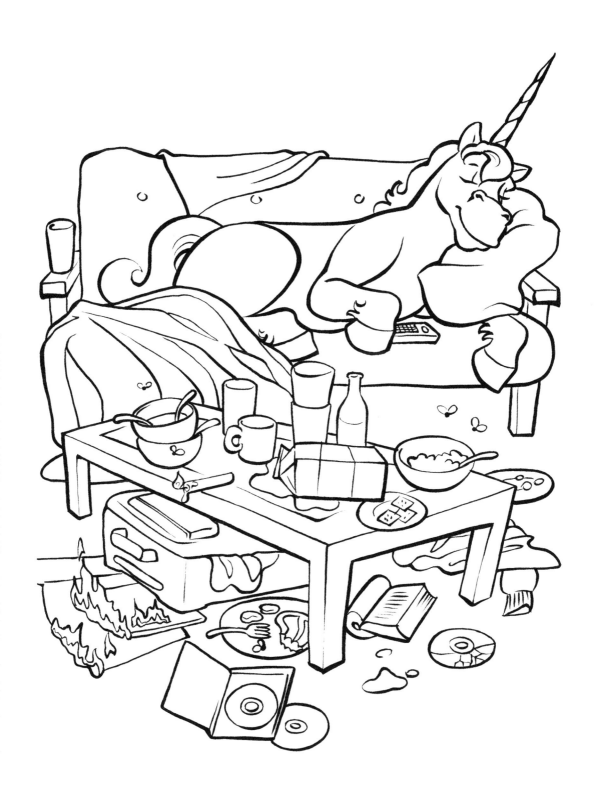

Unicorns are the worst house guests,
and they never leave.

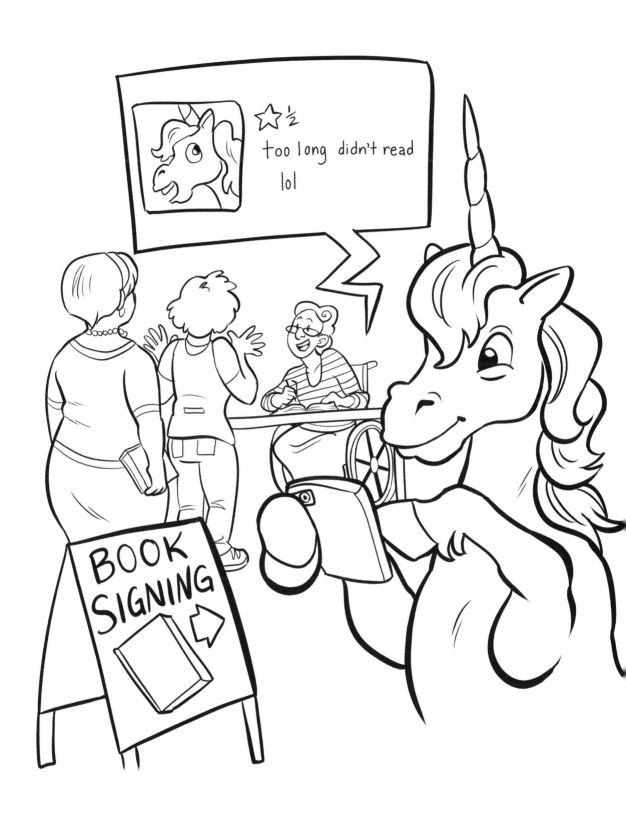

Unicorns leave negative reviews on books they haven't read.

Are you a unicorn?
Take this quiz to find out!

1) You forgot to bring your lunch to work. You...
 a. Buy yourself a lunch.
 b. Whine until your coworkers take pity and feed you.
 c. Eat your coworker's sandwich. I DON'T SEE YOUR NAME ON IT, SHARON.

2) Your good friend is moving! You...
 a. Show up bright and early to help them.
 b. Decline because you don't really feel like helping.
 c. Say you'll help, then change your mind without telling them.
 They'll get the point when you don't answer your phone, right?

3) You get in a heated argument with someone. You...
 a. Do your best to reason with them.
 b. Rage-quit the conversation.
 c. Pat them on the head and tell them they're cute
 when they're angry.

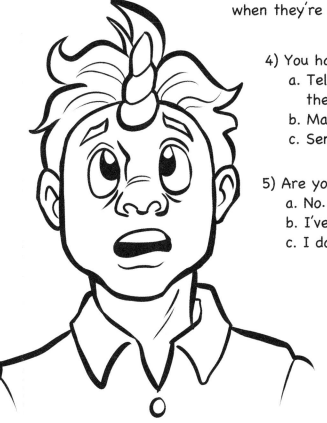

4) You have a crush on someone. You...
 a. Tell them how you feel and hope
 they feel the same way.
 b. Make innuendos at them constantly.
 c. Send them unsolicited horn pics.

5) Are you a literal unicorn?
 a. No.
 b. I've been known to fart glitter occasionally.
 c. I don't know, why don't you ask my HORN?

Answer Key
If you answered mostly a's, you are not a unicorn!
If you answered mostly b's, you might not be a
unicorn, but you sure act like one sometimes.
If you answered mostly c's, you're probably a unicorn.
You should work on that.

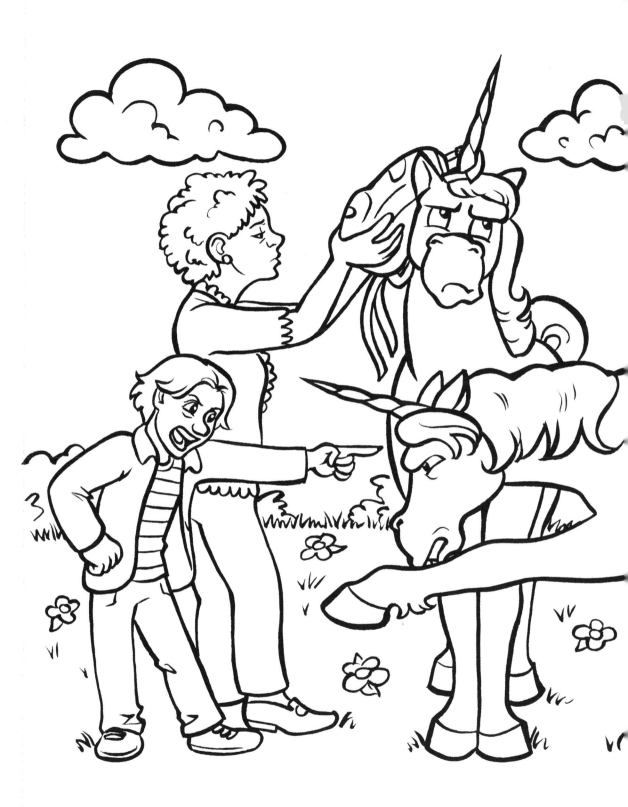

When you point out that unicorns are being jerks,
they act like YOU'RE the jerk.

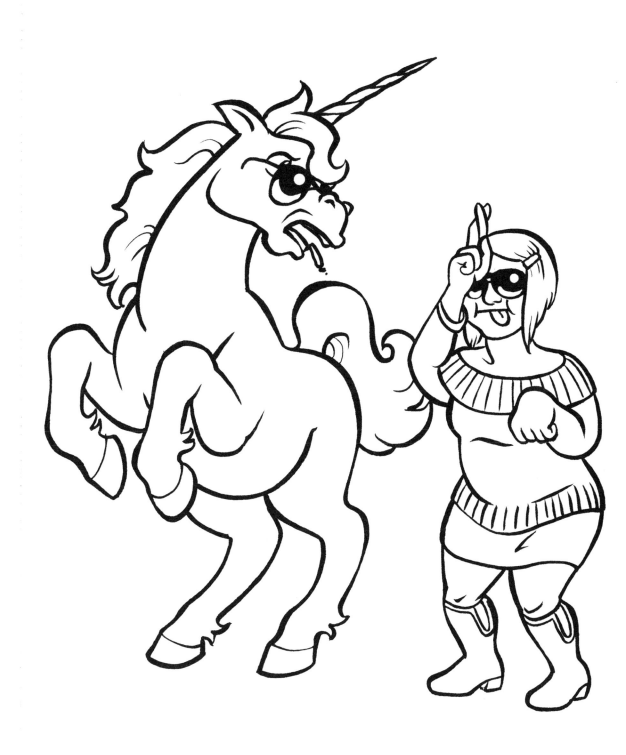

Don't be a unicorn.
Even unicorns don't appreciate it.

About the Artist

Theo is an artist, fantasy writer, and coloring book tycoon who lives in Saint Paul, Minnesota, with an abundance of toy unicorns (most of whom are okay, even if they can get kind of judgmental).

For more of Theo's work, check out *Mer World Problems: a coloring book documenting hardships under the sea*, *Dinosaurs with Jobs: a coloring book celebrating our old-school coworkers*, and *Fat Ladies in Spaaaaace: a body-positive coloring book*. There's also art and things at www.theonicole.com.

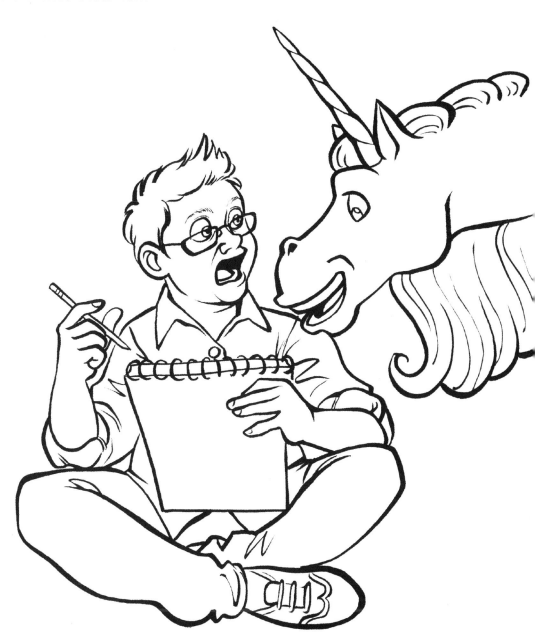

Copyright © 2012, 2017 by Theo Nicole Lorenz
Cover and internal design © 2017 by Theo Nicole Lorenz
Cover design by Theo Nicole Lorenz
Cover images/illustrations © Theo Nicole Lorenz

Sourcebooks and the colophon are registered trademarks of Sourcebooks, Inc.

This book is a work of humor and intended for entertainment purposes only.

Originally published as *Unicorns Are Jerks* in 2012 in the United States by Theo Nicole Lorenz with the CreateSpace Independent Publishing Platform.

Published by Sourcebooks, Inc.
P.O. Box 4410, Naperville, Illinois 60567-4410
(630) 961-3900
Fax: (630) 961-2168
www.sourcebooks.com

Printed and bound in the United States of America.
VP 10 9 8 7 6 5 4 3 2 1